An
Invitation
to
Dream

A BEDTIME
COMPANION TO
FILL YOUR SLEEP
WITH WONDER

WORKMAN PUBLISHING
NEW YORK

Copyright © 2018 by Workman Publishing Co., Inc.

Library of Congress Cataloging-in-Publication Data is available.

ISBN 978-1-5235-0473-2

Concept by Evan Griffith
Photo research by Anne Kerman
Cover photo: Norseman1968/Getty Images

Workman books are available at special discounts when purchased in bulk for premiums
and sales promotions as well as for fund-raising or educational use. Special editions or book
excerpts can also be created to specification. For details, contact the Special Sales Director
at the address below, or send an email to specialmarkets@workman.com.

Workman Publishing Co., Inc.
225 Varick Street
New York, NY 10014-4381

workman.com

WORKMAN is a registered trademark of Workman Publishing Co., Inc.

Printed in China
First printing September 2018
10 9 8 7 6 5 4 3 2 1

"It is a happiness
to **wonder**—
it is a happiness
to **dream**."

—EDGAR ALLAN POE

When I close my eyes,
I want to discover...

NEW WORLDS

"If we walk far enough,"

said Dorothy,

"we shall sometime come
to someplace."

—L. FRANK BAUM, *The Wonderful Wizard of Oz*

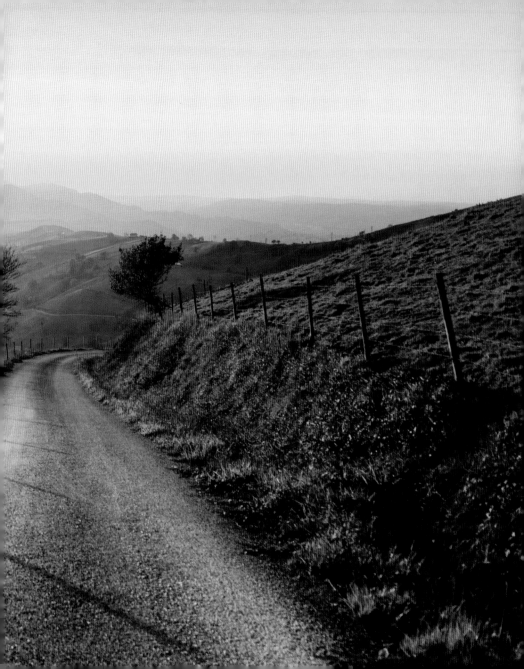

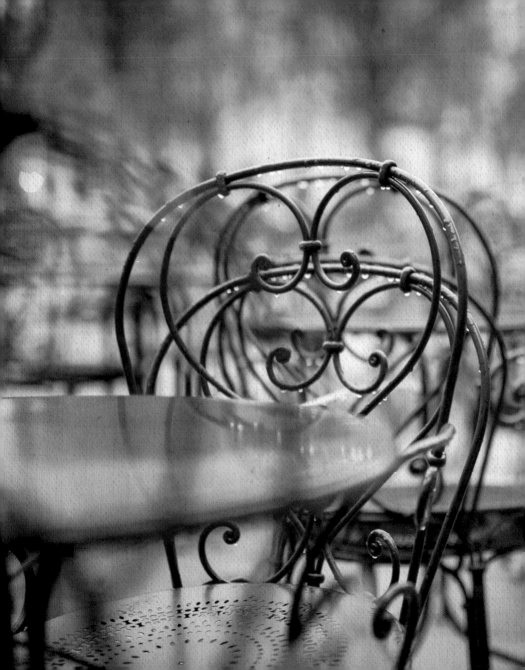

"Still, there are times I
am bewildered
by each mile I have
traveled, each meal I
have eaten, each person
I have known, each
room in which I have
slept. As ordinary as
it all appears, there
are times when it is
beyond my
imagination."

—JHUMPA LAHIRI,
Interpreter of Maladies

"The real voyage of
discovery consists not
in seeking new landscapes,
but in having new eyes."

—MARCEL PROUST

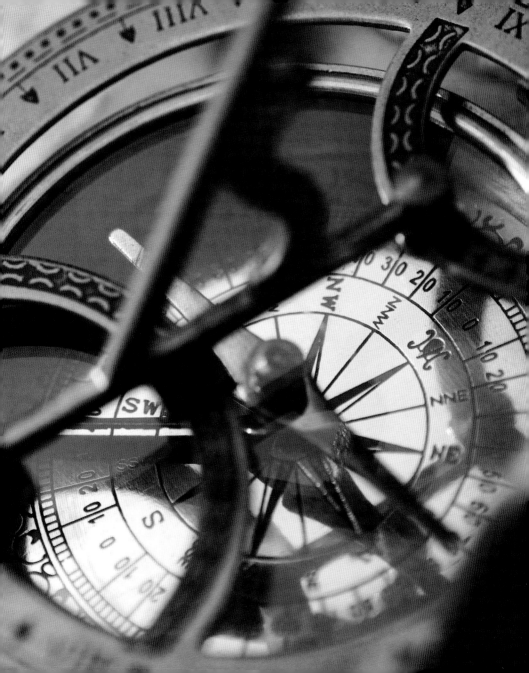

"And then she saw that there
was a light ahead of her;
not a few inches away where
the back of the wardrobe
ought to have been, but a
long way off. Something
cold and soft was falling
on her. A moment later she
found that she was standing
in the middle of a wood at
night-time with snow under
her feet and snowflakes
falling through the air."

—C. S. LEWIS,
*The Lion, the Witch
and the Wardrobe*

"To move, to breathe, to fly, to float,
To gain all while you give,
To roam the roads of lands remote,
To travel is to live."

—HANS CHRISTIAN ANDERSEN

"You seemed so far away,"

Miss Honey whispered, awestruck.

"Oh, I was.
I was flying past the stars
on silver wings,"

Matilda said.

"It was wonderful."

—ROALD DAHL, *Matilda*

"The most important reason
for going from one place
to another is to see
what's in between, and
they took great pleasure
in doing just that."

—NORTON JUSTER, *The Phantom Tollbooth*

"I have been feeling very clearheaded lately and what I want to write about today is the sea. It contains so many colors. Silver at dawn, green at noon, dark blue in the evening. . . . It is my favorite thing, I think, that I have ever seen. Sometimes I catch myself staring at it and forget my duties. It seems big enough to contain everything anyone could ever feel."

—ANTHONY DOERR,
All the Light We Cannot See

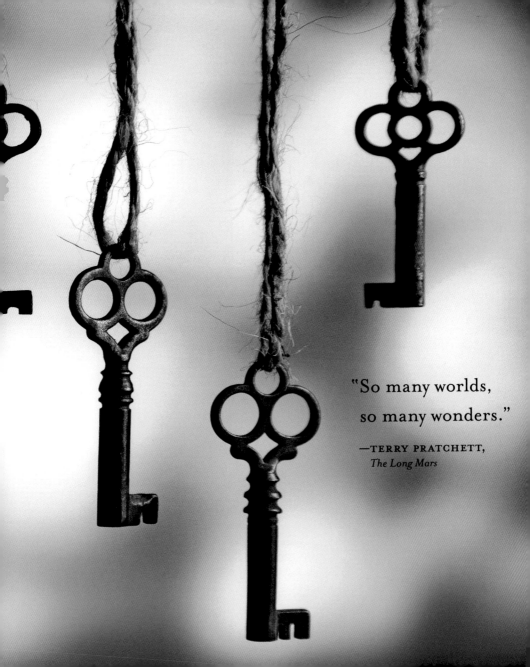

"So many worlds,
so many wonders."

—TERRY PRATCHETT,
The Long Mars

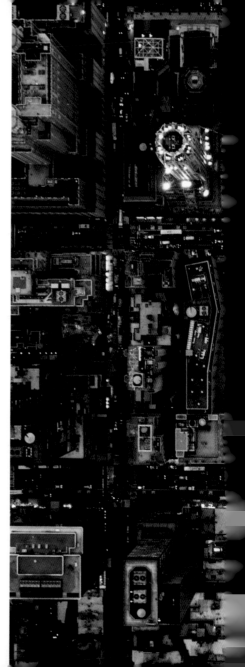

"You take **delight**
not in a city's seven
or seventy wonders,
but in the **answer**
it gives to a
question of yours."

—ITALO CALVINO, *Invisible Cities*

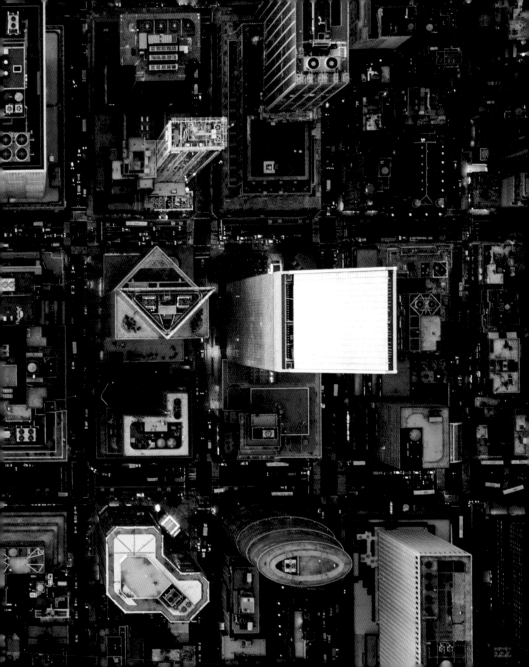

"He was alone. He was unheeded, happy, and near to the wild heart of life. He was alone and young and wilful and wildhearted, alone amid a waste of wild air and brackish waters and the sea-harvest of shells and tangle and veiled grey sunlight."

—JAMES JOYCE, *A Portrait of the Artist as a Young Man*

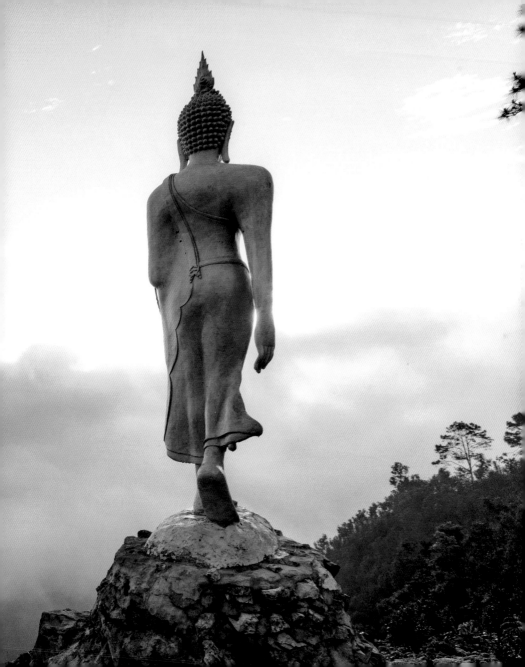

"We are not going in circles, we are going upwards. The path is a spiral; we have already climbed many steps."

—HERMANN HESSE, *Siddhartha*

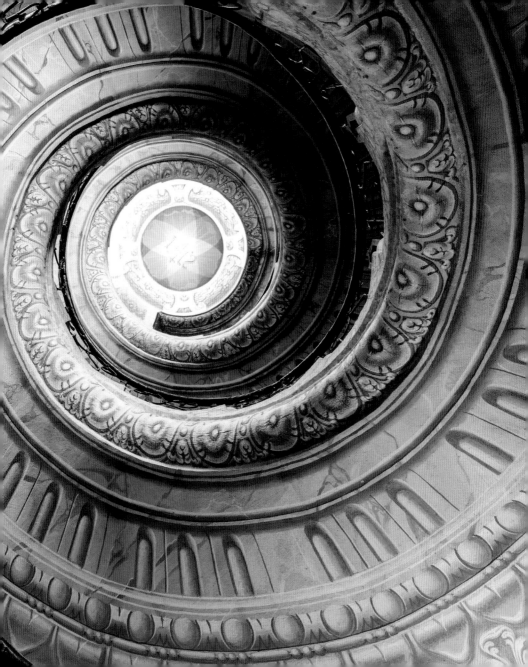

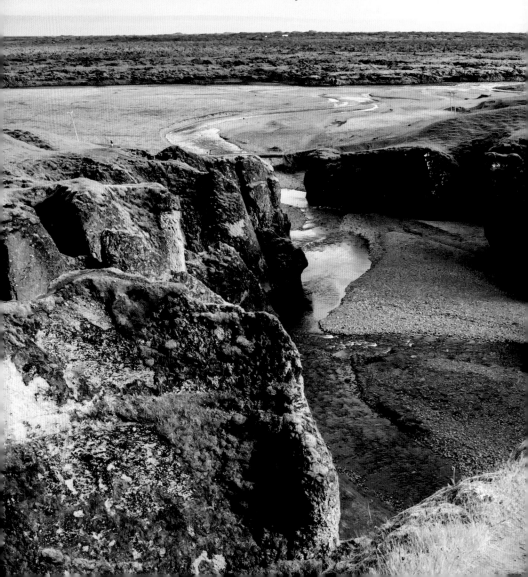

"The journey is the treasure."

—LLOYD ALEXANDER, *The Golden Dream of Carlo Chuchio*

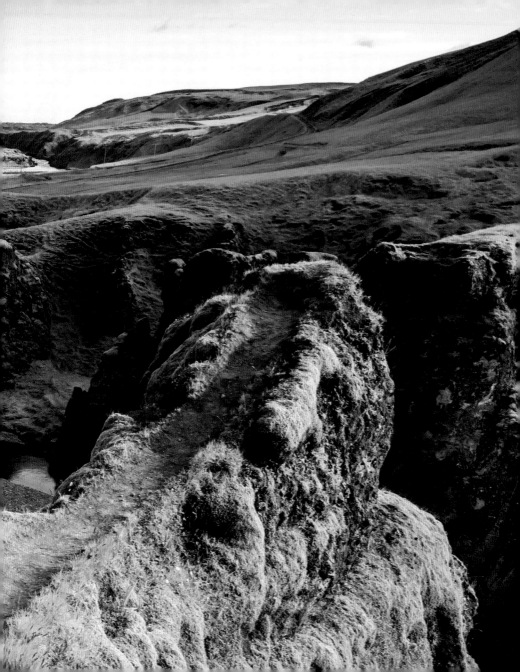

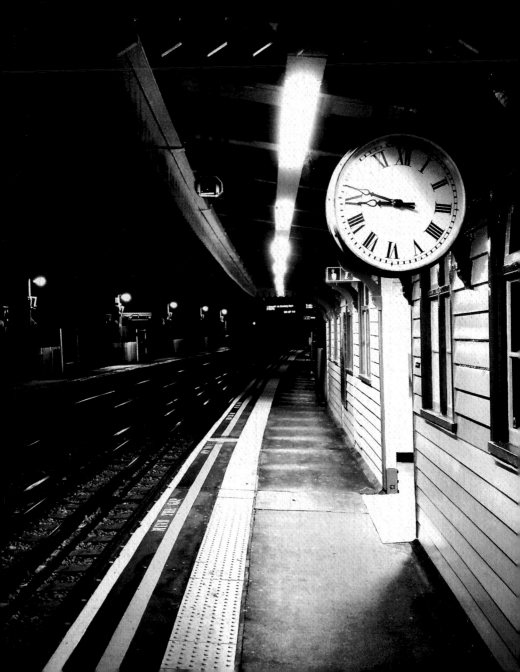

"Are you ready?"

Klaus asked finally.

"No," Sunny answered.

"Me neither," Violet said,

"but if we wait until we're ready we'll
be waiting for the rest of our lives.

Let's go."

—LEMONY SNICKET, *The Ersatz Elevator*

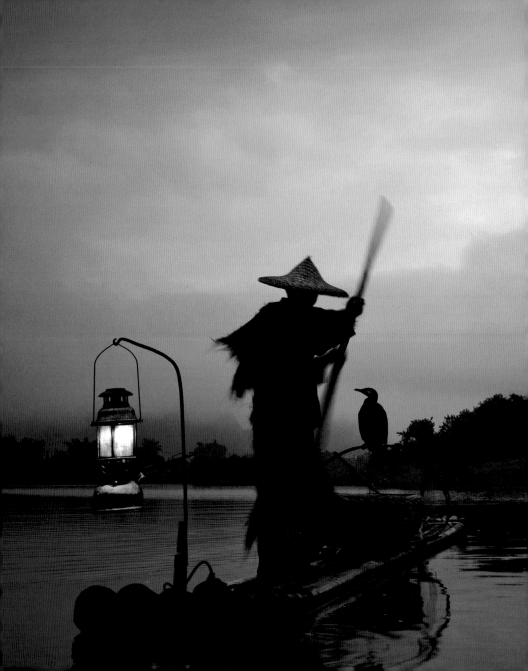

"Home is behind, the world ahead,
and there are many paths to tread
through shadows to the edge of night,
until the stars are all alight."

—J.R.R. TOLKIEN, *The Lord of the Rings*

MAGIC

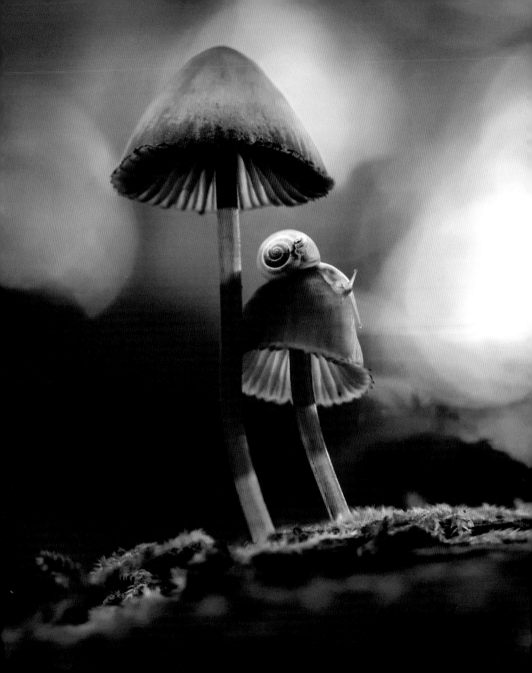

"Curiouser
and
curiouser!"
cried Alice.

—**LEWIS CARROLL,**
*Alice's Adventures
in Wonderland*

"I address you
all tonight
as you truly
are: wizards,
mermaids,
travelers,
adventurers,
and magicians.
You are the true
dreamers."

—BRIAN SELZNICK,
*The Invention
of Hugo Cabret*

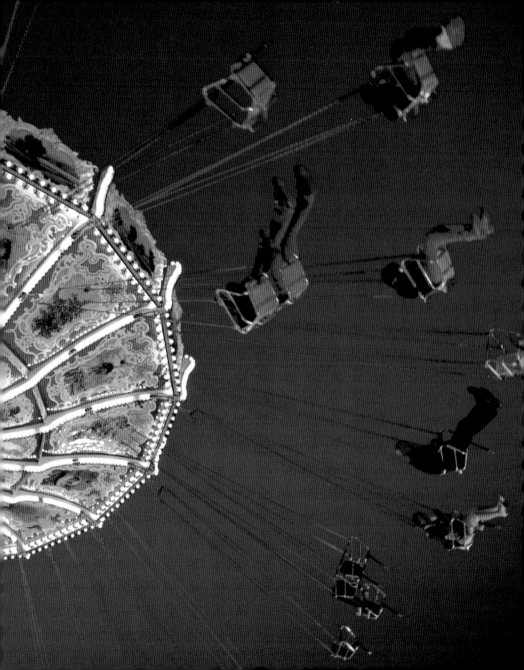

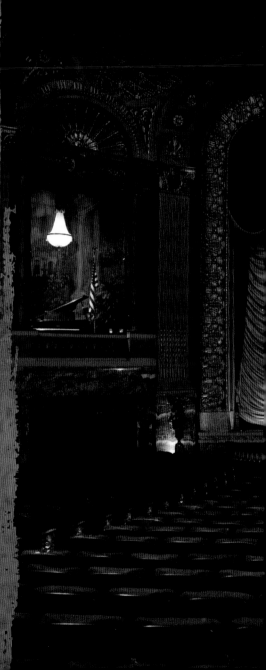

"Someone needs to
tell those tales.
When the battles are
fought and won and lost,
when the pirates find their
treasures and the dragons
eat their foes for breakfast
with a nice cup of Lapsang
souchong, someone
needs to tell their bits of
overlapping narrative.
**There's magic
in that.**"

—ERIN MORGENSTERN,
The Night Circus

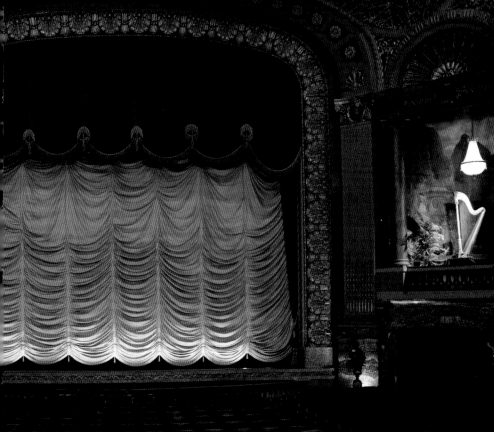

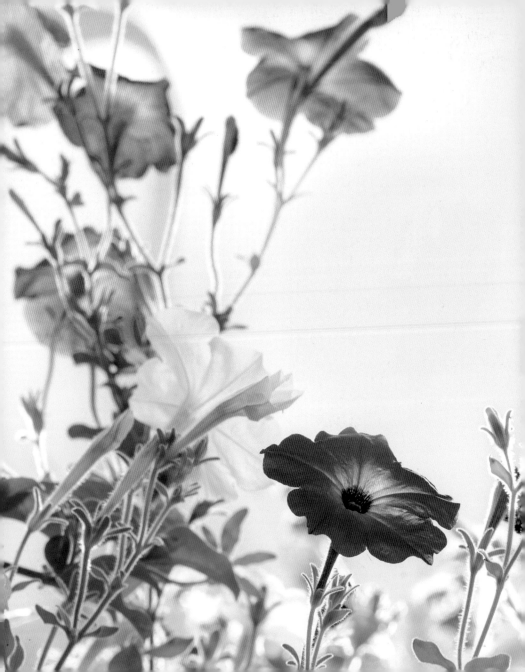

"Sometimes since I've been in the garden I've looked up through the trees at the sky and I have had a strange feeling of being happy as if something was pushing and drawing in my chest and making me breathe fast. Magic is always pushing and drawing and making things out of nothing. Everything is made out of Magic, leaves and trees, flowers and birds, badgers and foxes and squirrels and people. So it must be all around us. In this garden—in all the places."

—FRANCES HODGSON BURNETT, *The Secret Garden*

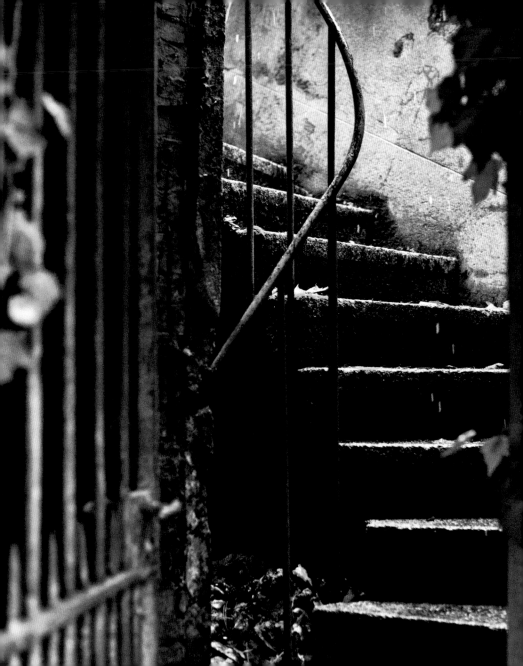

"If the path be beautiful,
let us not ask
where it leads."

—ANATOLE FRANCE

"Ah, music," he said, wiping his eyes. "A magic beyond all we do here!"

—J. K. ROWLING,
Harry Potter and the Sorcerer's Stone

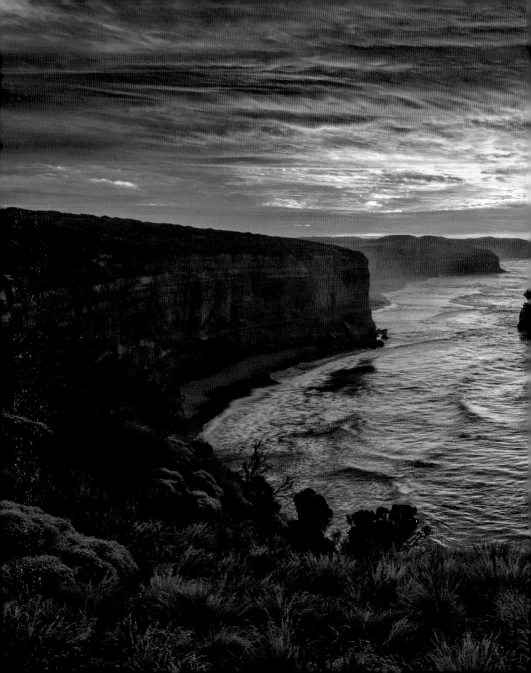

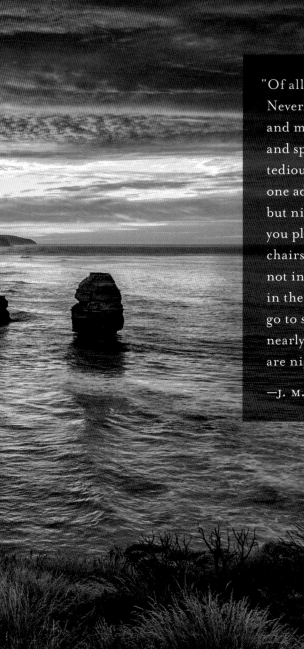

"Of all delectable islands the Neverland is the snuggest and most compact; not large and sprawly, you know, with tedious distances between one adventure and another, but nicely crammed. When you play at it by day with the chairs and table-cloth, it is not in the least alarming, but in the two minutes before you go to sleep it becomes very nearly real. That is why there are night-lights."

—J. M. BARRIE, *Peter Pan*

"To see a World in a Grain of Sand
And a Heaven in a Wild Flower,
Hold Infinity in the palm of your hand
And Eternity in an hour."

—WILLIAM BLAKE, *Auguries of Innocence*

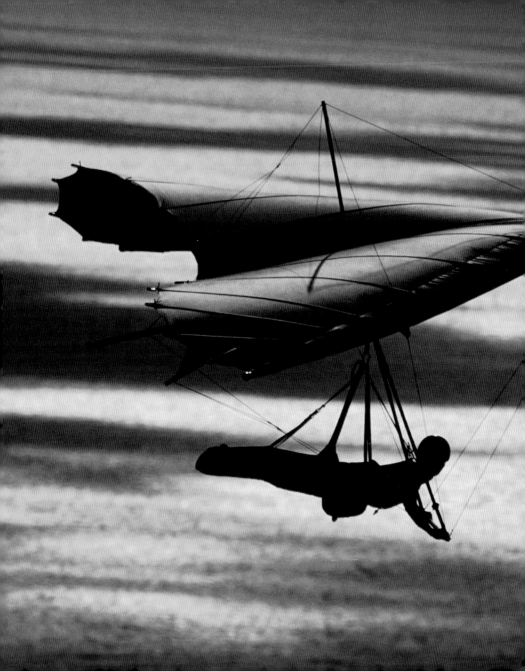

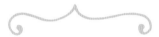

"Imagination is
the highest kite
that can fly."

—LAUREN BACALL,
By Myself and Then Some

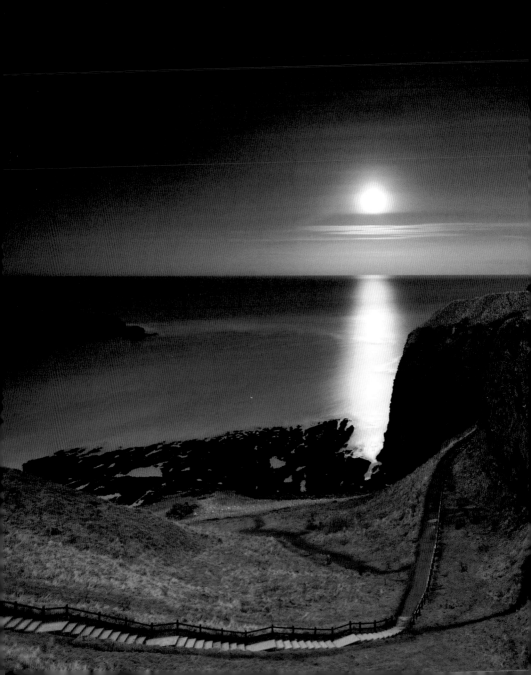

"Yes: I am a dreamer.

For a dreamer is one who can only find his way by moonlight, and his punishment is that he sees the dawn before the rest of the world."

—OSCAR WILDE, *The Critic as Artist*

"So rapid is the flight of our dreams upon the wings of imagination."

—ALEXANDRE DUMAS, *The Three Musketeers*

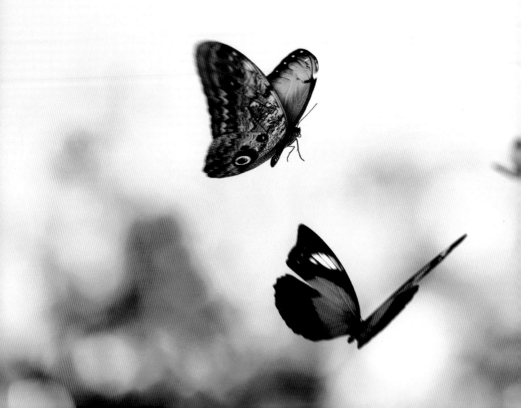

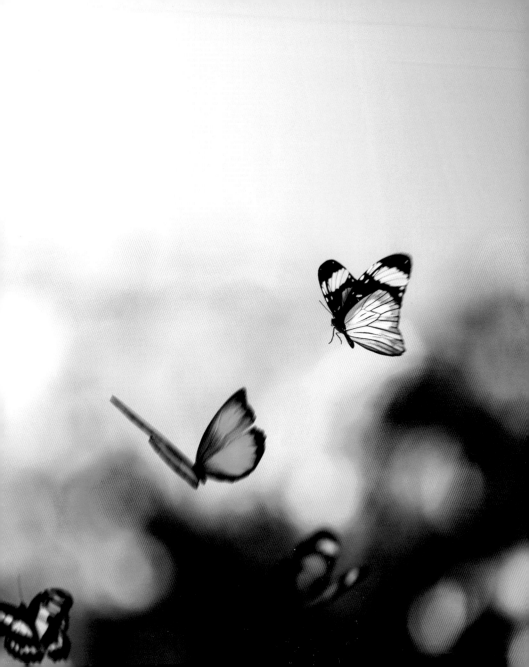

"There's no such thing as complete when it comes to stories. Stories are infinite. They are as infinite as worlds."

—KELLY BARNHILL, *Iron Hearted Violet*

"Fancies are like shadows . . .
you can't cage them, they're such
wayward, dancing things."

—L. M. MONTGOMERY, *Anne of Avonlea*

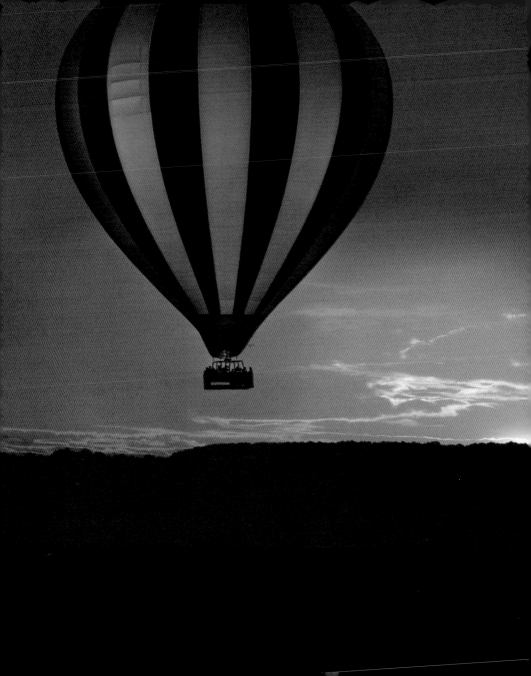

"People observe the colors of a day only at its beginnings and ends, but to me it's quite clear that a day merges through a multitude of shades and intonations, with each passing moment. A single hour can consist of thousands of different colors. Waxy yellows, cloud-spat blues. Murky darknesses."

—MARKUS ZUSAK, *The Book Thief*

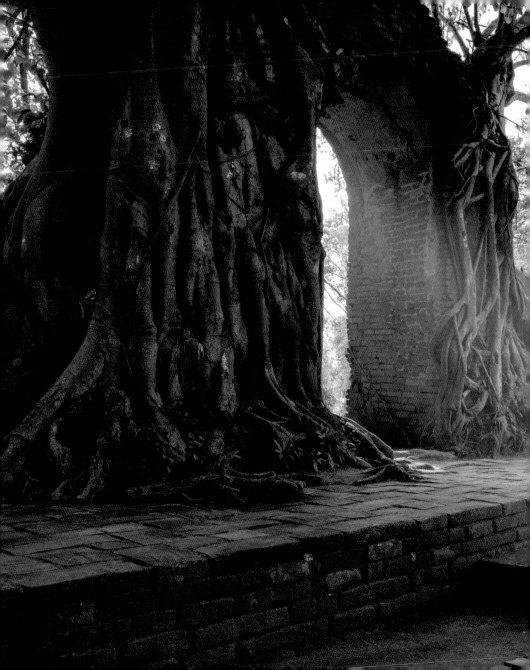

"If we shadows have offended,
Think but this, and all is mended,
That you have but slumber'd here
While these visions did appear.
And this weak and idle theme,
No more yielding but a dream,
Gentles, do not reprehend:
If you pardon, we will mend:
And, as I am an honest Puck,
If we have unearned luck
Now to 'scape the serpent's tongue,
We will make amends ere long;
Else the Puck a liar call:
So, good night unto you all.
Give me your hands, if we be friends,
And Robin shall restore amends."

—WILLIAM SHAKESPEARE,
A Midsummer Night's Dream

LOVE

"I think we dream so we don't have to be apart for so long. If we're in each other's dreams, we can be together all the time."

—A. A. MILNE, *Winnie-the-Pooh*

"The memories I value most,
I don't see them ever fading."

—KAZUO ISHIGURO, *Never Let Me Go*

"I've dreamt in my life dreams that have stayed with me ever after, and changed my ideas; they've gone through and through me, like wine through water, and altered the colour of my mind."

—EMILY BRONTË, *Wuthering Heights*

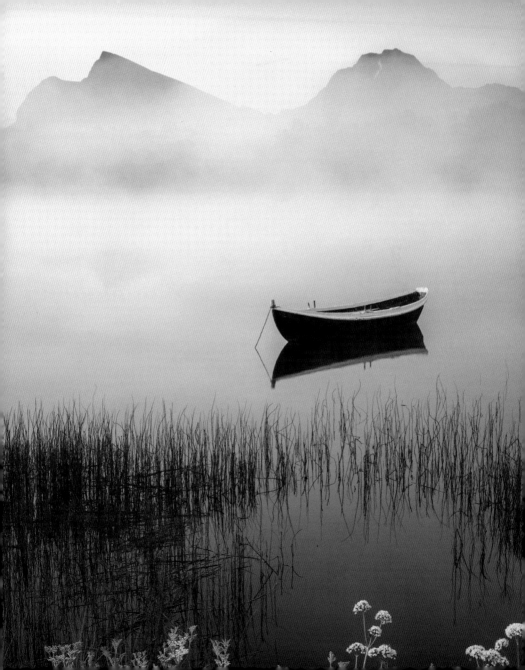

"And in that moment, I swear we were infinite."

—STEPHEN CHBOSKY, *The Perks of Being a Wallflower*

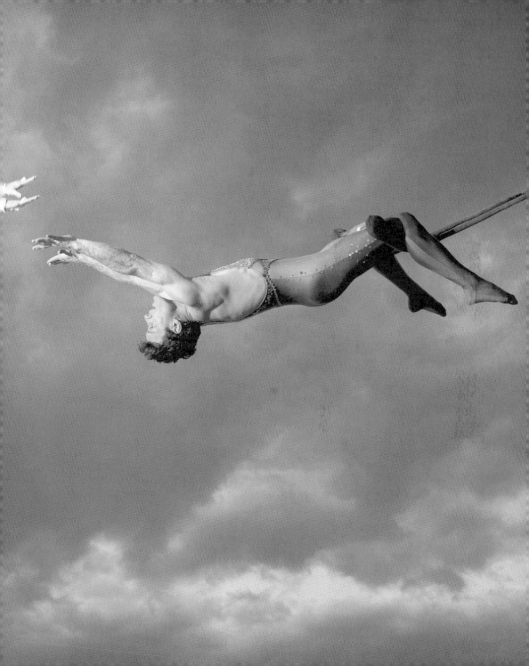

"How often have I
lain beneath rain
on a strange roof,
thinking of home."

—WILLIAM FAULKNER

"The summer sun was not meant for boys like me. Boys like me belonged to the rain."

—BENJAMIN ALIRE SÁENZ, *Aristotle and Dante Discover the Secrets of the Universe*

"Beauty is not caused. It is."

—EMILY DICKINSON

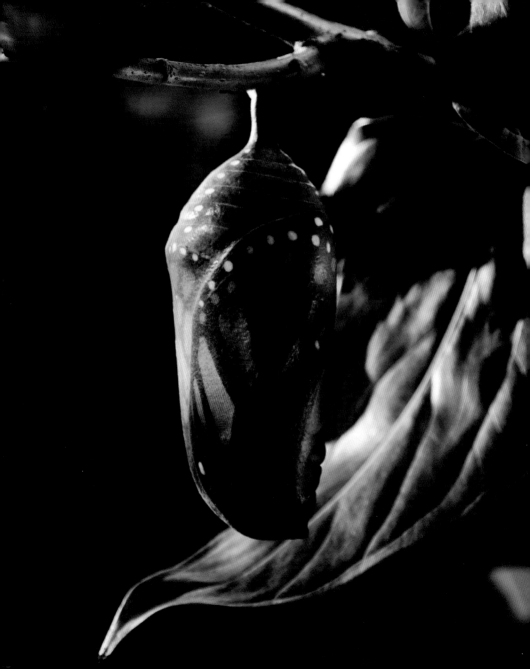

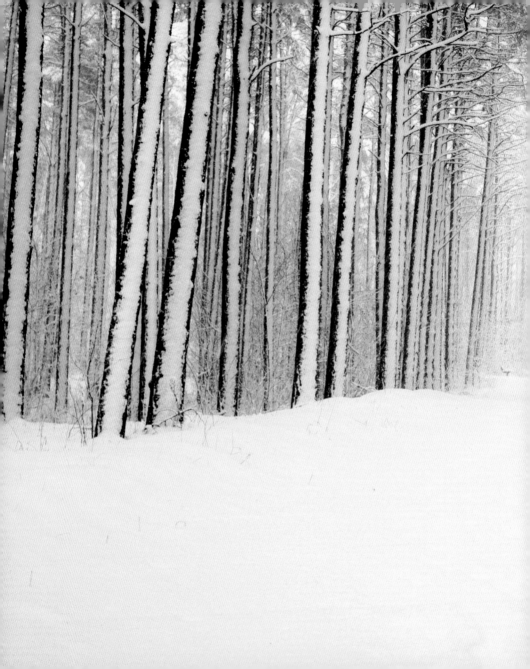

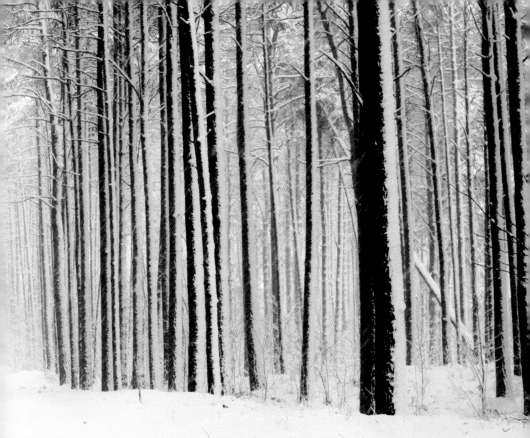

"With luck, it might even snow for us."

—HARUKI MURAKAMI, *After Dark*

"So, I love you because the entire universe conspired to help me find you."

—PAULO COELHO, *The Alchemist*

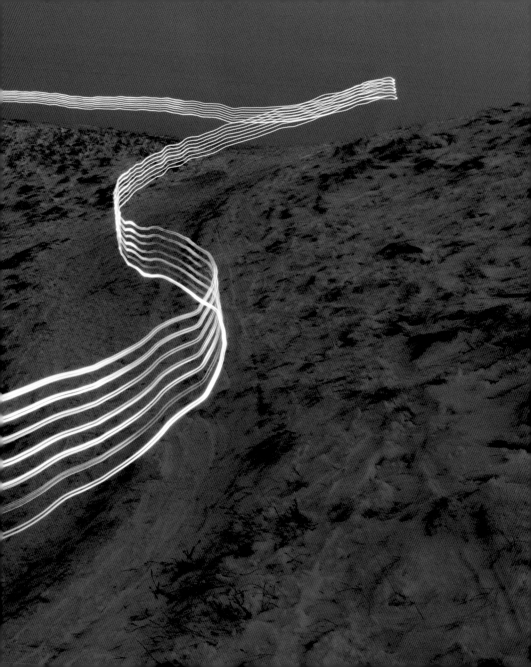

"I think . . . if it is true
that there are as many
minds as there are heads,
then there are as many
kinds of love as there
are hearts."

—LEO TOLSTOY,
Anna Karenina

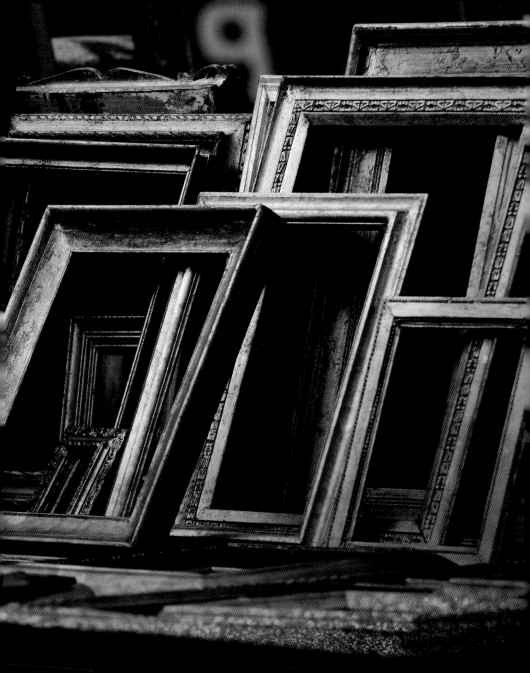

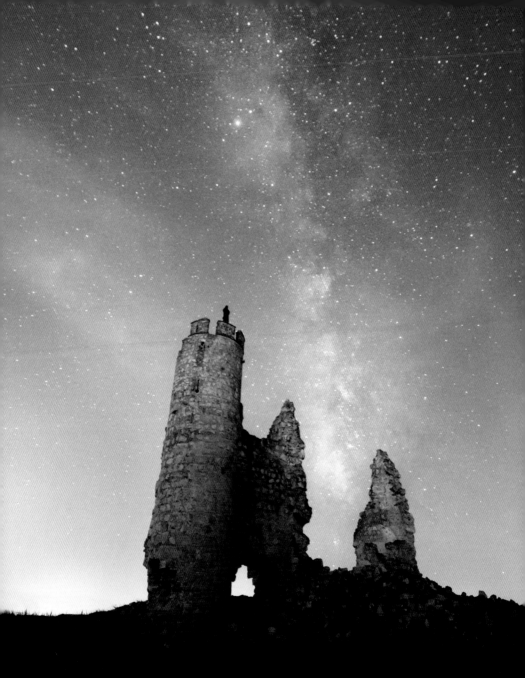

"He was walking
into Faerie, in search
of a fallen star."

—NEIL GAIMAN, *Stardust*

"I tried to discover, in the rumor
of forests and waves, words that
other men could not hear, and
I pricked up my ears to listen to
the revelation of their harmony."

—GUSTAVE FLAUBERT, *November*

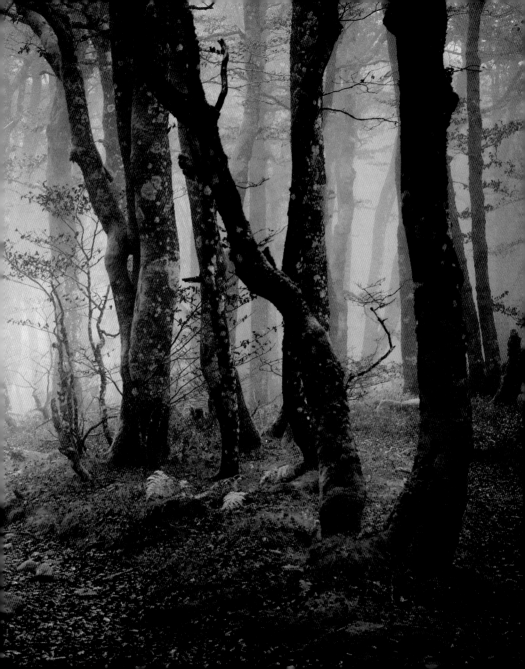

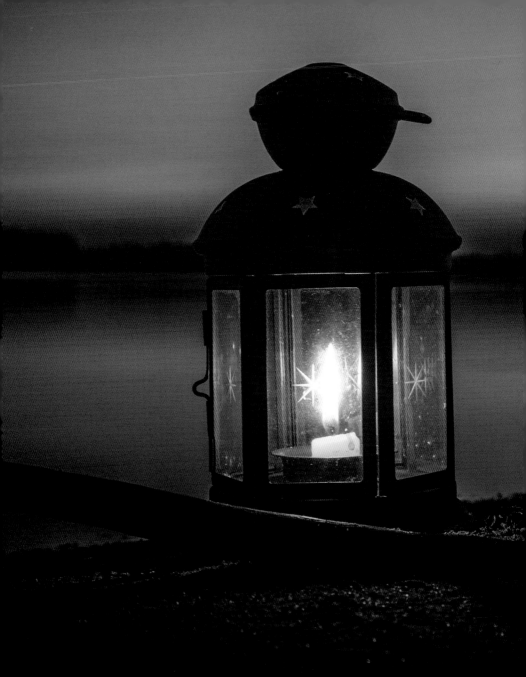

"I love you like certain dark things are loved,
secretly, between the shadow and the soul."

—PABLO NERUDA, *100 Love Sonnets*

MYSTERY

"The most wonderful
and the strongest
things in the world,
you know,
are just the things which
no one can see."

—CHARLES KINGSLEY, *The Water-Babies*

"We build this place
with the **sand of
memories**; these
castles are our memories
and **inventiveness**
made **tangible**."

—ANNE LAMOTT,
Bird by Bird

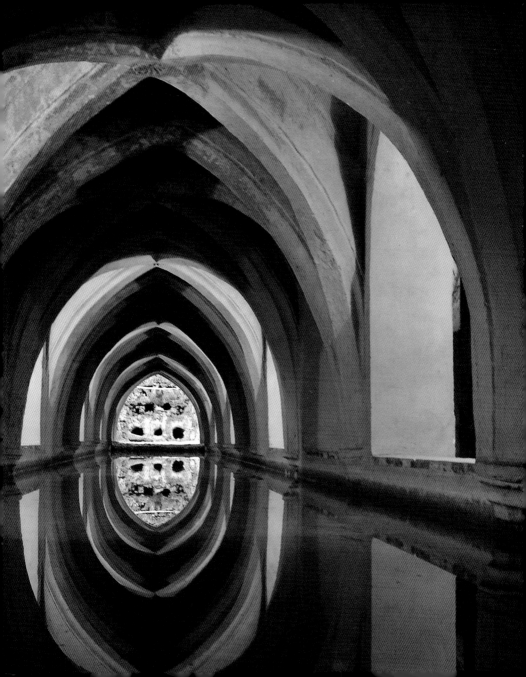

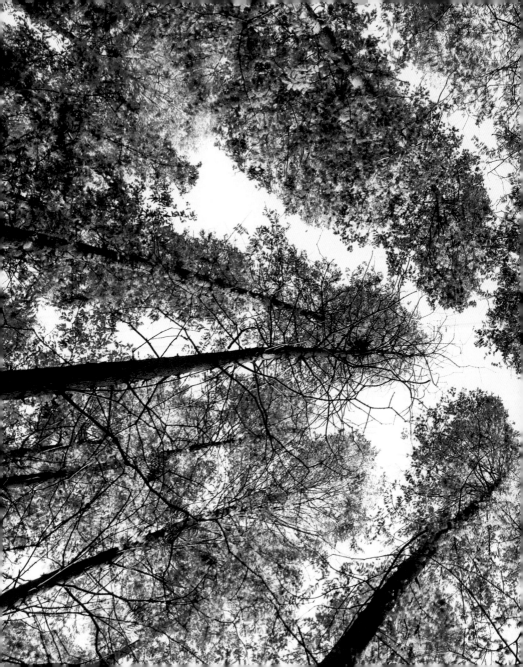

"Yet for the first time in three days, I want something. I want the forest lord to turn me into a cedar. The very oldest islanders say that if you are in the interior mountains on the night when the forest lord counts his trees, he includes you in the number and turns you into a tree."

—DAVID MITCHELL, *number9dream*

"Secrets are the kind of adventure she needs. Secrets are safe, and they do much to make you different. On the inside where it counts."

—E. L. KONIGSBURG, *From the Mixed-Up Files of Mrs. Basil E. Frankweiler*

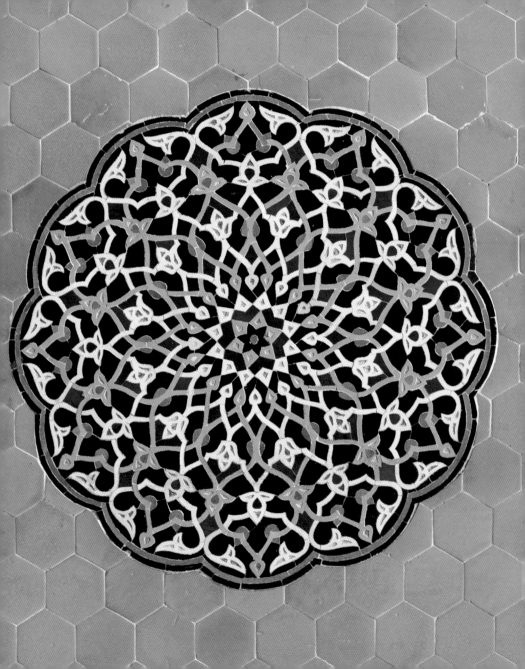

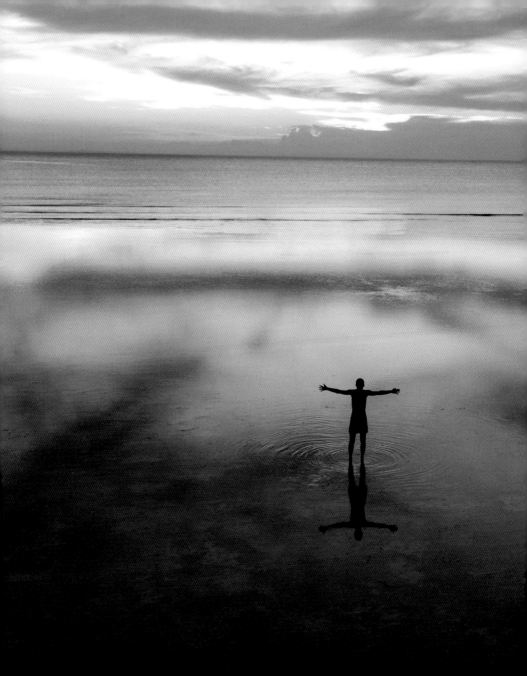

"We are an
impossibility in
an impossible
universe."

—RAY BRADBURY

"It began in **mystery**, and it will end in mystery, but what a **savage** and **beautiful** country lies in between."

—DIANE ACKERMAN, *A Natural History of the Senses*

"The rabbit-hole went straight on like a tunnel for some way, and then dipped suddenly down, so suddenly that Alice had not a moment to think about stopping herself before she found herself falling down a very deep well."

—LEWIS CARROLL,
Alice's Adventures in Wonderland

"Doesn't it seem to you,"
asked Madame Bovary,
"that the mind moves more
freely in the presence of that
boundless expanse, that the
sight of it elevates the soul
and gives rise to thoughts
of the infinite and the ideal?"

—GUSTAVE FLAUBERT, *Madame Bovary*

"There are really four dimensions, three which we call the three planes of Space, and a fourth, Time."

—H. G. WELLS, *The Time Machine*

"It was a rainy night. It was the myth of the rainy night."

—JACK KEROUAC, *On the Road*

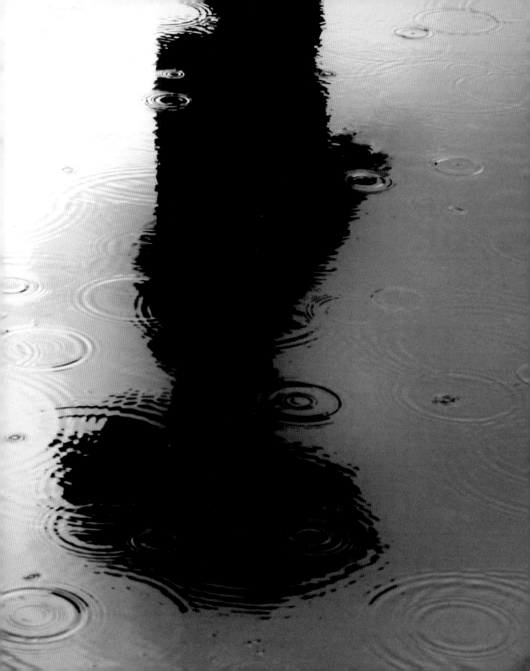

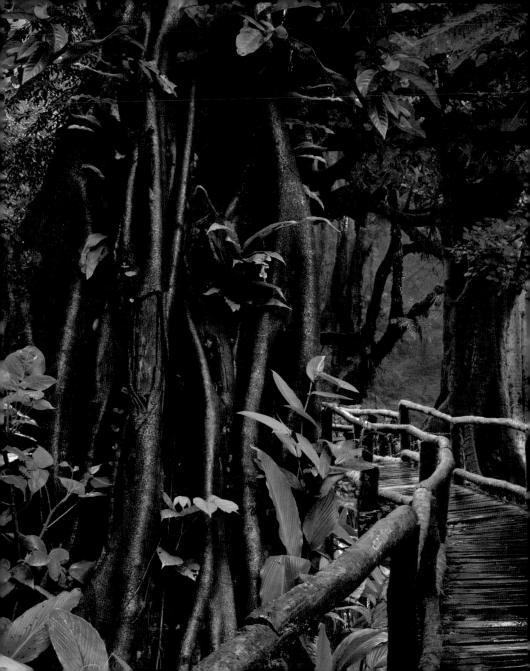

"We all have forests in our minds.
Forests unexplored, unending.
Each one of us gets lost in the
forest, every night, alone."

—URSULA K. LE GUIN,
The Wind's Twelve Quarters

"Vision is the art
of seeing things
invisible."

—JONATHAN SWIFT

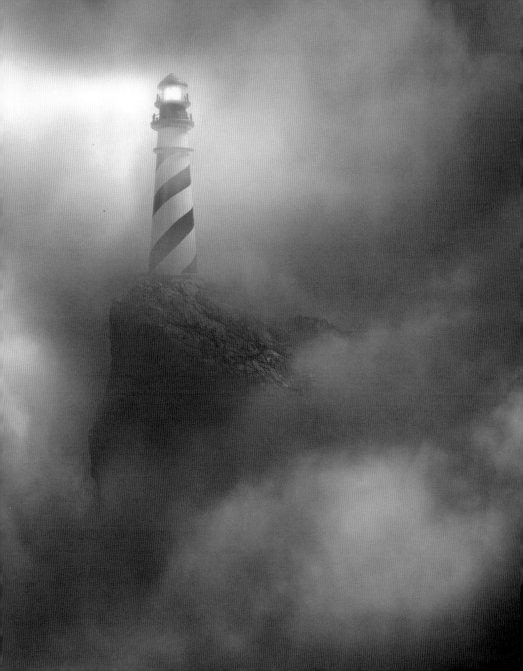

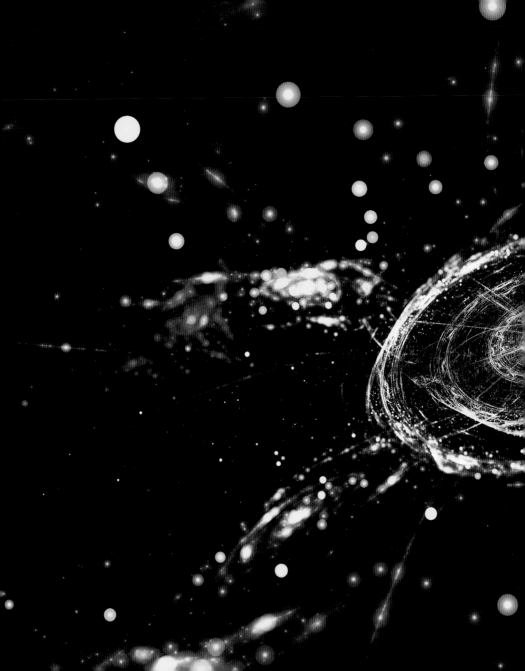

"If the doors of perception were cleansed, everything would appear to man as it is, infinite."

—WILLIAM BLAKE

"The river is everywhere at once, at the source and at the mouth, at the waterfall, at the ferry, at the rapids, in the sea, in the mountains, everywhere at once. . . ."

—HERMANN HESSE, *Siddhartha*

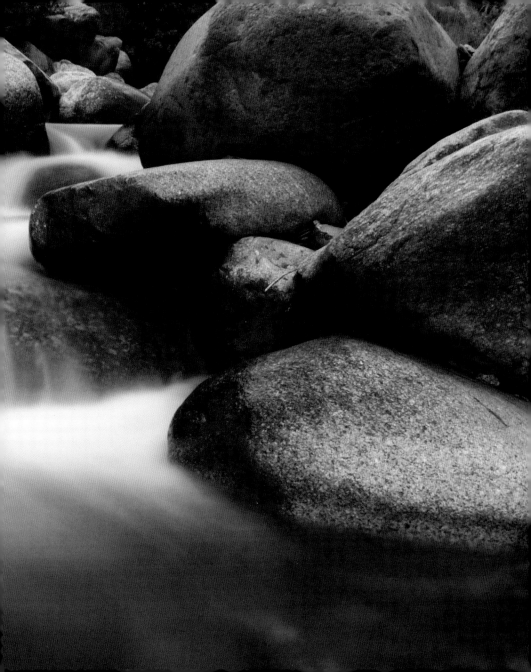

"At midnight, in
the month of June,
I stand beneath the
mystic moon."

—EDGAR ALLAN POE,
"The Sleeper"

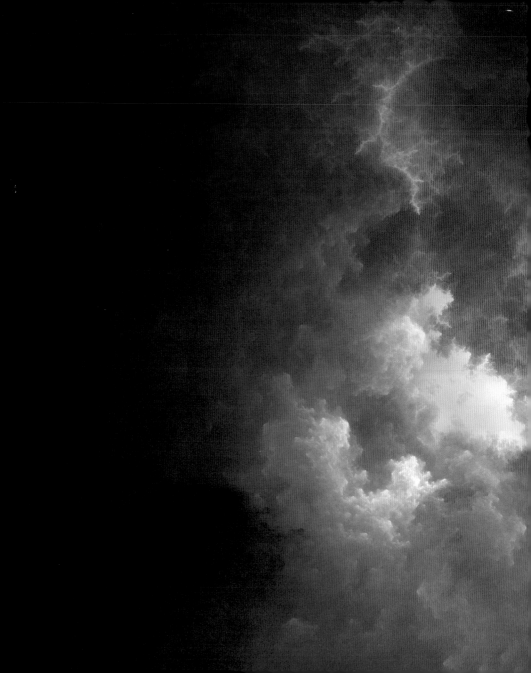

"Unfold your own myth."

—JALALUDDIN RUMI

PEACE

"Peace is always beautiful."

—WALT WHITMAN, *Leaves of Grass*

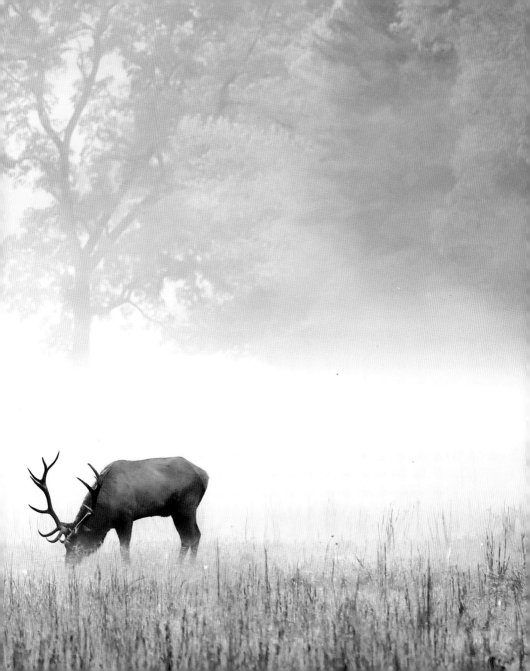

"I love to watch the fine mist of the night come on,
The windows and the stars illumined, one by one,
The rivers of dark smoke pour upward lazily,
And the moon rise and turn them silver. I shall see
The springs, the summers, and the autumns slowly pass;
And when old Winter puts his blank face to the glass,
I shall close all my shutters, pull the curtains tight,
And build me stately palaces by candlelight."

—CHARLES BAUDELAIRE, *Les Fleurs du Mal*

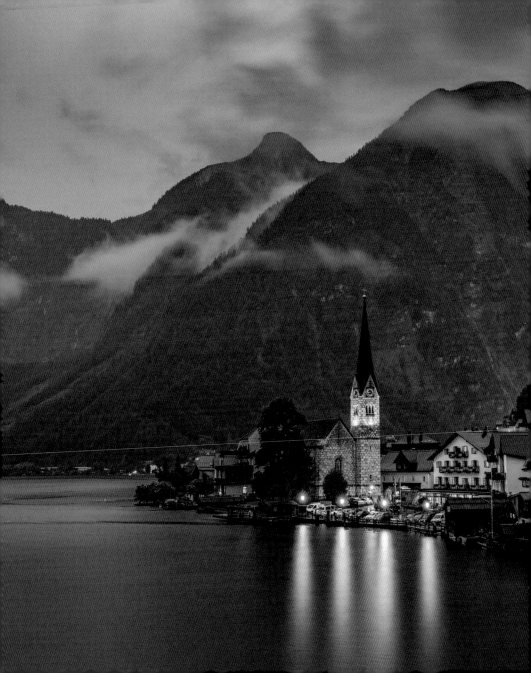

"Life seems to go on without effort, when I am filled with music."

—GEORGE ELIOT, *The Mill on the Floss*

"The rich meadow-grass seemed that morning of a freshness and a greenness unsurpassable. Never had they noticed the roses so vivid, the willow-herb so riotous, the meadow-sweet so odorous and pervading."

—KENNETH GRAHAME, *The Wind in the Willows*

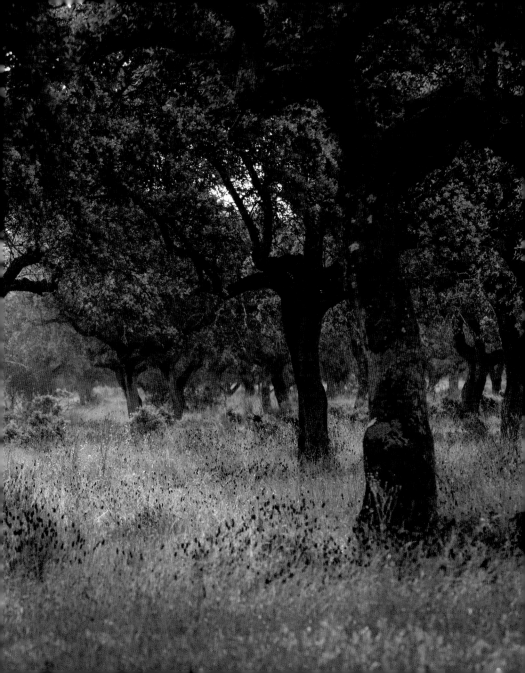

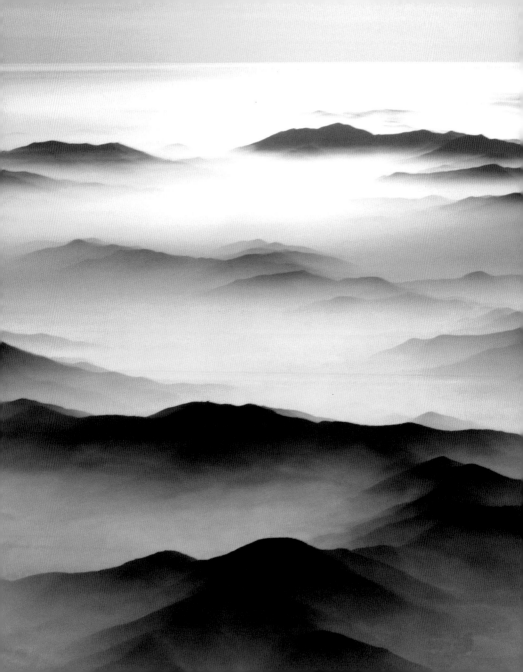

"Therefore am I still
A lover of the meadows and the woods,
And mountains; and of all that we behold
From this green earth; of all the mighty world
Of eye and ear, both what they half create,
And what perceive; well pleased to recognize
In nature and the language of the sense,
The anchor of my purest thoughts, the nurse,
The guide, the guardian of my heart, and soul
Of all my moral being."

—WILLIAM WORDSWORTH,
Lines Composed a Few Miles Above Tintern Abbey

"**Extraordinary** things
are always **hiding** in places
people never think to look."

—JODI PICOULT, *My Sister's Keeper*

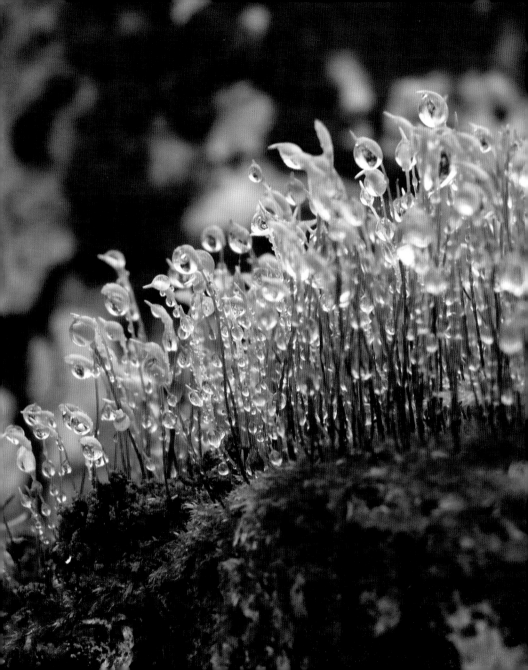

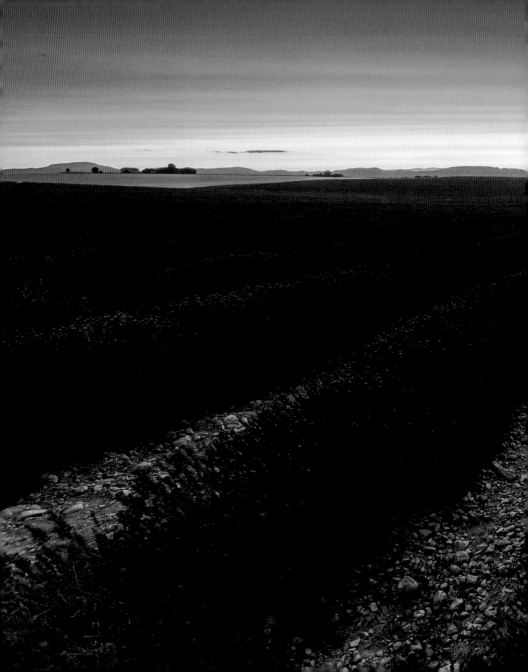

"Soon it got dusk, a grapy dusk, a purple dusk over tangerine groves and long melon fields; the sun the color of pressed grapes, slashed with burgundy red, the fields the color of love and Spanish mysteries."

—JACK KEROUAC, *On the Road*

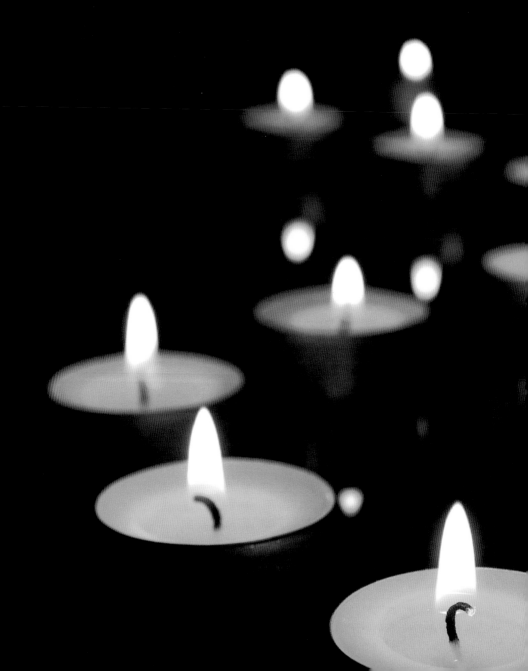

"I love the silent hour of night,
 For blissful dreams may then arise,
 Revealing to my charmed sight
 What may not bless my waking eyes."

—ANNE BRONTË

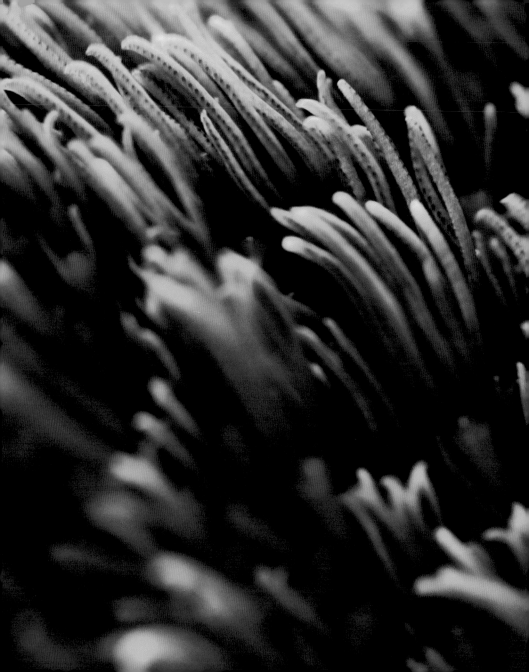

"Water always goes where it **wants to go**, and nothing in the end can stand against it. Water is **patient.**"

—MARGARET ATWOOD, *The Penelopiad*

"Live in each season
as it passes; breathe
the air, drink the drink,
taste the fruit, and
resign yourself to the
influence of the earth."

—HENRY DAVID THOREAU

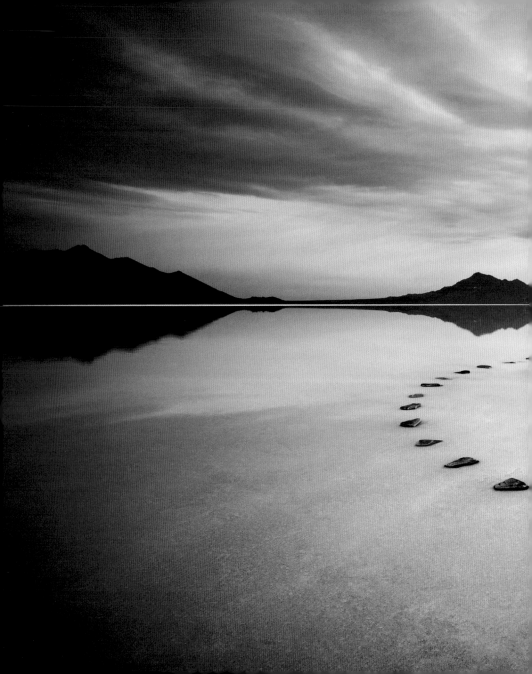

"The sky grew darker, painted blue on blue, one stroke at a time, into deeper and deeper shades of night."

—HARUKI MURAKAMI, *Dance Dance Dance*

"The villages were lighting
up, constellations that greeted
each other across the dusk.
And, at the touch of his finger,
his flying-lights flashed back
a greeting to them. The earth
grew spangled with light
signals as each house lit its
star, searching the vastness
of the night as a lighthouse
sweeps the sea. Now every place
that sheltered human life was
sparkling. And it rejoiced him
to enter into this one night
with a measured slowness,
as into an anchorage."

—ANTOINE DE SAINT-EXUPÉRY,
Night Flight

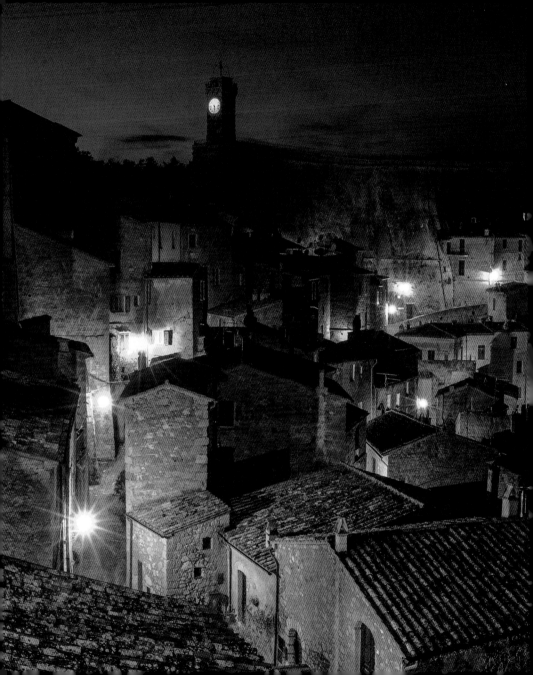

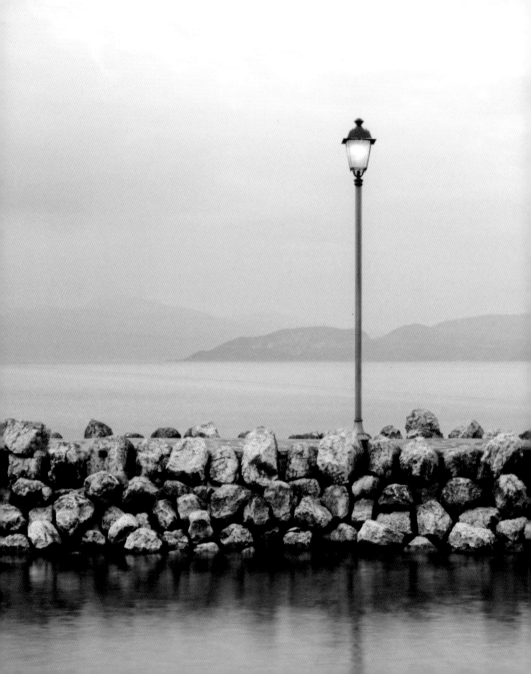

"We are such stuff as dreams are made on,
and our little life is rounded with a sleep."

—WILLIAM SHAKESPEARE, *The Tempest*

PHOTO CREDITS